J. M. W. TURNER

The 'Wilson' Sketchbook

with an introduction by
Andrew Wilton

THE TATE GALLERY

ISBN 1 85437 002 2
Published by order of the Trustees 1988
Copyright © 1988 The Tate Gallery All rights reserved
Designed and published by Tate Gallery Publications,
Millbank, London S W1P 4R G

The production of this book has been
supported by P A Consulting Group

PA

The 'Wilson' Sketchbook

This little book, modest though it is in size, marks an important stage in the development of Turner's practice as a draughtsman. It includes notes connected with his tour of the north of England in the summer of 1797, and some jotted indications of financial transactions in November and December of that year, so that we can safely assume that he was using it about then. But with a single possible exception the elaborate coloured drawings it contains do not relate to his northern tour; indeed, they are not of the type that he would have made on one of the lengthy sketching trips round Britain that occupied him so frequently in the 1790s. For those purposes, he almost invariably worked in pencil alone, making outline drawings of places he visited and only occasionally working them up with watercolour into something more elaborate. He never, of course, 'finished' a work on the spot:

that was a task for the winter days when the contents of the sketchbooks would be ransacked for subject-matter, either at the behest of patrons commissioning particular views, or for Turner's own purposes as a regular exhibitor at the spring exhibitions at the Royal Academy.

Only the year before, in 1796, he had in fact broken his established practice of sending in topographical watercolours to that exhibition by showing an oil painting, a moonlight marine which he called 'Fishermen at sea' (B & J 1) – not at all his usual thing. It prompted some enthusiastic comment at the time and even today, in the long perspective of Turner's work throughout a lifetime of change and experiment, it remains a remarkable exercise in atmospheric evocation and the accurate depiction of natural phenomena. If the steadily increasing technical and conceptual powers manifested in the exhibited watercolours had not already made the point, 'Fishermen at sea'

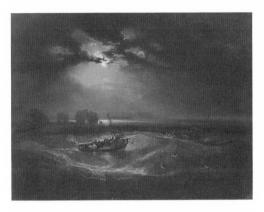

J.M.W. Turner, *Fishermen at Sea* 1796

clearly showed that Turner was a young artist –
he was just twenty-one when it went on public
display – of exceptional vision and proficiency.

At first sight it is difficult to imagine how the
polished accomplishment of 'Fishermen at sea'

could have emerged out of the work he had been engaged on previously. The picture represents a leap that can only be understood after a careful examination of the watercolours that preceded it. They reveal an extraordinarily wide-ranging and adventurous eye and a quite exceptionally inventive and daring hand, exploiting the traditional vocabulary of the topographical view to express aspects of landscape hitherto undescribed in watercolour: subtle effects of light, windy weather, rough seas. In the winter of 1795–6, when 'Fishermen at sea' was being painted for the Academy exhibition, Turner translated an already immensely various and flexible visual language from watercolour into oil. We have almost no evidence that he had used the medium before: there is a record of a 'view of Rochester Castle, with fishermen drawing their boats ashore in a gale of wind', though there remains no trace of this; and we possess a small painting on paper,

unambitiously showing a watermill among foliage and datable to 1792–3. Yet here, in a single essay, he proved his ability to produce a dramatically lit marine subject at a level of expressive power and technical competence that placed him at once among the finest landscape painters of the eighteenth century. The concern with light and shade, the evocative and naturalistic handling of moonlight (deliberately contrasted with lantern-light) show that he was consciously emulating both the Frenchman Vernet and the Englishman Joseph Wright. His sights were set ambitiously high, and, despite his lack of experience with oil, he knew that he could effectively challenge the masters he so deliberately followed.

Yet there is a quality in 'Fishermen at sea' which is missing from the output of the older painters. It is altogether more realistic, more true to observed life and more fundamentally a record of what is there; considering Turner's lifelong

obsession with the concept of the painting as High Art, it is a surprisingly uncomplicated, blunt statement of fact. The sources of inspiration that were to mean so much to him a year or two later – Richard Wilson and, shortly after, Claude – play no part in the genesis of this canvas. Vernet and Wright are challenged but not imitated. In this way, too, 'Fishermen at sea' is a highly original work, and can perhaps be seen as an early example of the romantic naturalism that was to find its supreme expression, not in the paintings of Turner, but in those of his great contemporary Constable.

Even so, it was appropriate that this first exhibited oil painting should have demonstrated Turner's firm commitment to reality. The grandeur, even the theatrical artificiality, of his mature work rests on a foundation of intense observation: the most transcendental of his late studies of light and atmosphere are, in their essentials, attempts

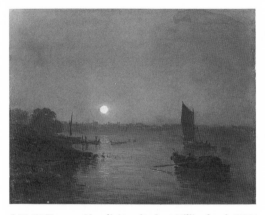

J. M. W. Turner, *Moonlight, a Study at Millbank* exh. 1797

to paint the visual splendours of nature as they really are. But he quickly moved away from the direct statement of 'Fishermen at sea' towards a more picturesque and self-consciously effect-seeking landscape style. A small panel, 'Moonlight,

a study at Millbank' (B & J 2) appeared at the Academy in 1797 to reinforce the original point – indeed, it is likely that this modest essay actually preceded 'Fishermen at sea' and functioned as a study preparatory for it: it is a much more literal pastiche of the style of Wright of Derby, or perhaps of that rather pedestrian painter of night scenes, Abraham Pether. Turner would not have wanted to show it in the exhibition with the bigger picture because it was, after all, an experiment in the same genre and would have diluted the impact of the more developed work. But he also showed in 1797 a second marine, a scene of 'Fishermen coming ashore at sun set previous to a gale' (B & J 3), in which (the original is unfortunately lost) he worked out what was clearly an even more elaborate climatic scenario. There were, too, several watercolours as usual, including impressive ecclesiastical interiors which, like the moonlights, exploited chiaroscuro in a

manner that some critics found reminiscent of Rembrandt.

The experience of working in oil on canvas or wood panel seems, then, to have involved Turner in much careful thought as to the nature and potential of tonality in painting. Traditionally, watercolour was a medium of relatively limited tonal range, exploiting the whiteness of the paper and the transparency of the pigment to achieve its effects of light. A pervasive bland sunshine is accordingly the normal illumination for eighteenth-century topographical views. It was only relatively recently, in the work of John Robert Cozens, that the medium had been used for more complex emotional purposes; and not until the 1790s did artists begin to experiment extensively with various ways of making watercolour do the job of oil paint. In painting night scenes on canvas, Turner was maximising the benefit of working on a dark, as opposed to a light, ground. Having brought watercolour to

such heights of expressive flexibility, he would naturally have revelled in the potential of a medium with quite other capabilities.

The 'Wilson' sketchbook is the record of Turner's new sense of excitement at the possibilities of working with a dark ground. Its pages are themselves washed over with earth colour – a reddish-brown wash which forms the ground tone for each of its studies, and which Turner was often to employ in his sketchbooks in the future. It provided an obvious analogy with the traditional dark ground of oil painting, and could be used as a base for bodycolour (gouache), the more opaque medium in which watercolour pigments are mixed with powdered clay or lead white to produce a brighter colour that does not rely on the brilliance of the paper itself for its luminosity. In the 'Wilson' sketchbook Turner tries it for the first time. And the range of subjects that he records in the book reflects the exploratory moment: there are

seascapes – storms and calms – clouds, sunsets, tree studies, animals, figures, interiors, street scenes and snow scenes (rare in Turner's output); all recorded in rich colour, and often presented as complete miniature pictures in their own right, spreading across two of the book's very small pages.

The instinctive arranging of his subjects into organised compositions is typical of Turner's sketching method; and he was later to produce many books of beautifully integrated and satisfying studies from nature like this. But in few books do we find such a variety of scenes and compositional types. If we were in any doubt that Turner is here consciously planning finished works – whether in oil or watercolour – we should be convinced by the label that he himself attached to the green vellum cover: *84 Studies for Pictures* / [*Cop*]*ies of Wilson*. The number refers to the system whereby Turner kept all his sketchbooks (there were almost three hundred in his house

when he died) accessible as reference tools. The phrase 'Studies for Pictures' is one that he sometimes applied to books in which his drawings bear a particularly close relationship to the processes by which he evolved finished compositions, usually of a non-topographical kind. The 'Copies of Wilson' provide further testimony to the phase of studenthood which the book represents in Turner's development. Wilson, a Welshman by birth, was the supreme exponent of landscape painting in eighteenth-century Britain: Gainsborough, though admirable, had confined himself to the Picturesque modes derived from the Dutch, and had eschewed the more 'serious' idealising forms evolved in seventeenth-century Italy by Claude Lorraine and Nicolas Poussin. It was Wilson who had given English landscape a new respectability by adapting Claudean formulas and Italianate subject-matter to modern uses. He had demonstrated that landscape can be an art form of the

highest seriousness, capable of conveying profound emotion, especially when it uses the associations of Antique topography or classical mythology. These aims were entirely congenial to Turner, whose lifelong ambition was to show the world that landscape painting can be a vehicle for the noblest and most sublime ideas. For the first few years of Turner's career as a painter, Wilson was quite explicitly his hero and his chief model.

There are five memoranda of compositions by Wilson in this book, all, significantly, of Italian, or Italianate, scenes which sum up Wilson's particular contribution to the development of ideas about landscape (pp. 78–9, 86–7, 92–3, 98–9 and 100–101). There is also a copy (pp. 104–5) of a composition apparently by Claude-Joseph Vernet: a Mediterranean coastal scene with a ship being careened, which helpfully documents the other obvious influence on these early phases of Turner's progress as a painter. Vernet was Wilson's

[15]

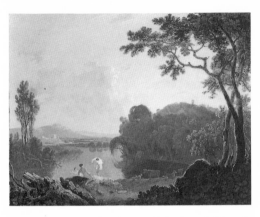

Richard Wilson, *Landscape with Bathers, Cattle and Ruin c.*1770–5

Continental opposite number, an artist who was held by his contemporaries to have brought Claude's practice into the present; he specialised in coastal subjects of the kind Turner copies here, probably using a print as his source, as he may

have done with some of the Wilsons, though his use of colour in transcribing most of them suggests that he saw at least some of the originals. One, that on pp. 78–9 of the sketchbook, belonged to the Prince of Wales, as did probably another, that copied on pp. 86–7. The 'Convent on the Rock' copied on pp. 98–9 was in the collection of the President of the Royal Academy, Benjamin West. It was usual for painters to obtain permission to copy works in private collections, and Turner, who had been attached to the Royal Academy since he joined its Schools in the winter of 1789, would have been well placed to arrange introductions to those he wished to study. The memory of these Wilsons was to remain with him all his life: as late as 1847, when he was seventy-two, he could write to a friend about to visit Wales, 'I do not think you could have hit upon a more desirable spot for your pencil and hope you may feel – just what I felt in the days of my youth when I was in

search of Richard Wilson's birthplace'. And al-
though some of the early excitement that Wilson
aroused in him was shortly to be overlaid by a
deeper acquaintance with the work of Claude him-
self, the motifs that Turner copied from Wilson in
this book recur in unexpected guises throughout
his work, and even his attitude to Claude is fre-
quently tinctured with a Wilsonesque prejudice
that seems to have been conditioned specifically
by pictures like the ones he recorded here, with
their characteristic circular temples and ancient
bridges. A similar copy, evidently made about the
same time, displays the same general concerns: it
is a little watercolour note (TB XXXIII–I) of Wilson's
'River with bathers, cattle and a ruin' (Constable
99b).

There are other loose sheets that relate to draw-
ings in the 'Wilson' sketchbook; notably a series
of studies of fishing-boats being beached or put to
sea. These (TB XXXIII) are executed in the same

[18]

watercolour and bodycolour as the sketchbook drawings, and have much the same atmosphere. One of them (TB XXXIII–K) shows a boat in a rough sea, with the letters BRI . . . TON painted on its transom. This has led commentators to believe that the studies were made at Brighton; but it seems more probable that the letters should be read as the name of the boat, not its port of origin: it is the 'Briton', and came from Margate, if the 'Wilson' sketchbook is to be believed; for it contains among its studies of fishermen and their boats a view (p. 114) of a sunset over the Margate cliffs with the twin spires of Reculver Church in the distance. The study on pp. 82–3 is also, apparently, a view at Margate, showing the harbour from the sea. These topographical hints are sufficient to confirm that all the coastal scenes recorded here were observed in or near Margate, which would, indeed, be natural enough since Turner had maternal relatives in Margate with whom he

had occasionally stayed since childhood. Further views of the Margate coastline occur in another book which Turner himself associated with Brighton, the 'Studies near Brighton' book (TB xxx) which must have been in use about the same time. Later in his life he was to make Margate almost a second home, visiting it regularly by steamer, and praising the Thanet skies as the most beautiful in Europe.

Turner's interest in the Margate skies explains the genesis of the marine that he showed at the Academy in 1797, the 'Fishermen coming ashore at sun set, previous to a gale', which came to be called 'The Mildmay Sea-piece' after its first owner, Sir John Mildmay. Its composition is known today only through the mezzotint after it which Turner published in 1812, as a plate in his 'Liber Studiorum' (R. 40). This shows that some of the figures in the picture were studied on pages in the 'Wilson' sketchbook (pp. 14, 16, 17), so that

the book may have been in use in the winter of 1796–7, when the Mildmay Sea-piece was being painted. In that case, it would be tempting to suppose that some of the marine studies, among which one (pp. 66–7) is a moonlight, may also be associated with 'Fishermen at sea'; but this would necessitate the book's having been in use over a period of at least two years.

There is nothing inherently improbable in this, except that the flood of Turner's creative activity at the time would in all likelihood have led him to fill such a book more rapidly. But there are distinctions to be made between the various groups and types of sketches to be found in it, which may indicate that he put it down and picked it up again at intervals. The drawings made in and around Margate are less richly coloured and elaborately worked than some of the others, and it is possible that the book was used on a visit to the Kent coast in the autumn of 1796 and again, elsewhere, in the

autumn and winter of 1797. The second group of drawings include a number of beautifully-wrought church interiors which reflect Turner's preoccupation with such subject-matter at this time: his interior of Westminster Abbey, 'St Erasmus and Bishop Islip's Chapel' had been exhibited in 1796, as had one of two views of the Transept and Choir of Ely Cathedral. The second version of this subject appeared the following year, along with 'Transept of Ewenny Priory, Glamorganshire', one of the grandest of Turner's early church interiors, and the 'Choir of Salisbury Cathedral' which was one of a series of views of that church on which he was engaged in these years.

But the interiors in the 'Wilson' book are not, apparently, of such grand buildings. They show parish churches, packed with their congregations for Mattins or Evensong, glimmering with their monuments and hatchments, shadowy and impressive as age-old centres of worship, but not

sublime in the manner of Ely or Salisbury. One of them, that on pp. 26–7, shows a Communion service taking place, and, like the Mildmay Sea-piece, became the subject of one of the 'Liber Studiorum' plates. An oil study also exists (B & J 24), illustrating the close connection that existed in Turner's mind between these detailed studies in bodycolour and the possibility of executing the same subjects in oil. It is a relationship between the media which is unique to this stage of his development.

The question remains: in which churches did he make these passionately observed studies? As yet, we have no certain knowledge of his movements in the months covered by the 'Wilson' sketchbook, apart from the extended tour of the north of England that he made in the summer of 1797 (and which perhaps gave rise to the drawing on pp. 94–5), and a stay at Norbury, in Surrey, in the autumn of that year. We do know, however, that he went on a tour of north Kent in the spring

of 1798, while staying with a friend, the Rev. Robert Nixon at Foot's Cray near Orpington. But the Kent views in the 'Wilson' sketchbook are decidedly autumnal and breathe a very different spirit from those produced the following year (T B xxvi). Turner's trip to Margate did overlap with this, though; it seems to have involved him in a journey along the north Kent coast, including the Thames estuary and perhaps the mouth of the Medway at Rochester. The study of a neolithic monument on p. 61 almost certainly shows Kit's Coty, a cromlech in north-west Kent near Aylesford on the Medway. We may deduce from this that the estuary views in the sketchbook were also probably made on the Thanet trip, and show scenes on the Thames or the Medway between London and Margate. Most of the remaining drawings in the book are apparently views in that part of Kent which was closest to London: Greenwich (pp. 4–7, 50–1) and Lewisham (pp. 62–5). There

are several drawings that can be identified fairly certainly as being of Greenwich and its neighbourhood: that on pp. 4–5 is a view from Blackheath with St Paul's visible in the distance; and on the next two pages a study of trees includes the silhouette of one of the towers of Greenwich Hospital, and so was probably made in the same area. On pp. 50–1 there is a sketch which seems to show the Hospital again, with Greenwich Observatory, from Croom's Hill, and the panorama of London on pp. 56–7 may be that from Nunhead Hill nearby. The street scenes, including those in snow, are, of course, more difficult to identify; but it is suggested that those on pp. 62–5 were drawn on the southern side of Blackheath, going down to Lewisham. That on p. 64 shows a kiln which recurs in a composition study that Turner made for a pupil to copy (TB XXXI–G) inscribed *Lewisham*. The hills of north-west Kent were an obvious location for the young artist's excursions from central

London, affording as they did (and still do) some of the finest views of the city and its environs; they were also, of course, on the route from London to Margate, and it is possible that the whole book was used in the course of a journey there. The interiors would then be those of churches in north Kent, from Lewisham to the North Foreland. They are most likely to have been parishes close to London.

But there is at least one drawing which reminds us that Turner's centre of operations was central London itself, and that he planned his campaigns from a studio in Covent Garden – the tiny room he occupied at the top of his parents' house in Maiden Lane. On pp. 46–7 there is a view of St James's Park with Westminster Abbey in the distance, executed in pencil and white chalk, rather more summarily than the majority of the drawings in the book, and so presumably not in the context of the Kent excursion. It implies that the sketch-

book was one used close to home, and kept in the artist's pocket, as its diminutive size would suggest, for noting ideas immediately relevant to his current concerns. It is a working notebook in which the pressing demands of an increasingly fertile imagination are given expression as it forges a new language for itself: a language that was radically to affect the history of both watercolour and oil painting in the romantic period and long afterward.

Abbreviations

B & J This refers to the numbering of the oil-paintings
in Martin Butlin and Evelyn Joll, *The Paintings of
J. M. W. Turner* (2nd Ed., London and New
Haven, 1984).

W. This refers to the numbering of the watercolours
in Andrew Wilton, *The Life and Work of J. M. W.
Turner R.A.* (London 1979).

R. This refers to the numbering of the mezzotint
engravings of *Liber Studiorum* by W. G.
Rawlinson in *Turner's Liber Studiorum*, 2nd Ed.
(London 1906).

TB The works on paper in the Turner Bequest as
listed in A. J. Finberg, *A Complete Inventory of
the Drawings of the Turner Bequest* (London,
2 vols. 1909).

Bound in green vellum with one brass clasp, 63 leaves of blue laid paper prepared with a red-brown wash, size of sheet 113 × 93 ($4\frac{7}{16}$ × $3\frac{11}{16}$)

Page numbers are those given in Finberg's *Inventory* and stamped on each leaf (recto and verso) of the sketchbook.

Inside front cover: Inscr. in pen and brown ink:
'2866 4 Decr. 97
6906 8 Dc. 97
6765 3 Nov. 97
4459 / Decr. 97'
Endorsed by the Executors in ink

p.1 *Shipping at sea under a cloudy sunset sky*
 watercolour and bodycolour

p.2 ⎫ *Study of cloudy sunset sky over dark sea, with a*
p.3 ⎬ *ship in sunlight* watercolour and bodycolour
p.4 ⎫ *View from Blackheath, with St Paul's in the*
p.5 ⎬ *distance?* watercolour and white chalk
p.6 ⎫ *Trees against a sunset sky, with part of*
p.7 ⎭ *Greenwich Hospital beyond* watercolour

p.8 *Sunset at sea, with a lighthouse and ship*
 watercolour and bodycolour

p.9 *Study of trees* pencil and white chalk

p.10 *Soldiers resting, in historical costume* pen and
 brown ink, brush and black ink, watercolour and
 bodycolour

p.11 *Slight sketch of a sailing boat* pencil and white
 chalk

[32]

[33]

by Turner on pp. 78–79; an alternative source
might be the engraved version of this picture
made by Joseph Farington and published by
Boydell, 1776

[35]

with watercolour and bodycolour; a second
very slight study to the left

p. 121 Blank; offset from p. 128

p. 122 *A three-masted ship with sails set* pencil and
watercolour with white bodycolour

p. 123 Blank; slight offset from p. 122

p. 124 *A three-master with sails set* pencil and
watercolour with white bodycolour

p. 125 *Slight pencil diagram of a moulding(?) and a
plan(?)* pencil. Inscr.: *O Humphry(?)* and,
upside down: *St Noots(?)*

p. 126 *Slight study of branches* black chalk. Inscr.:
(?)*Yorkshire*
(?)*6*
(?)*43*

p. 127 Inside back cover
Inscr. (upside down):

?	Howden	
? Staford	Ely	
?		
? Lincoln	York	
?	Knares[borough]	
? - - - - - y	Rippon	Selby
? Mon Ch	Dunstanborough	
? Barrow Ch	Richmond	Swale(?)
?	Durham	
?		

8 { ?
? [the left-hand list almost
? completely illegible]
Beverly

The 'Wilson' Sketchbook

XXXVII

2860
986
205 3
453

N.º 361 —
66 Case of Sketches

No. 361

639

XXXVII

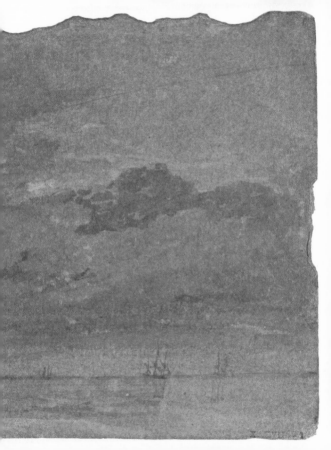

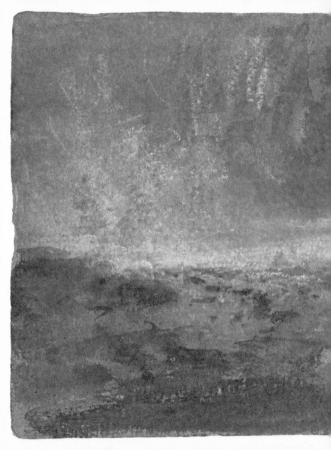

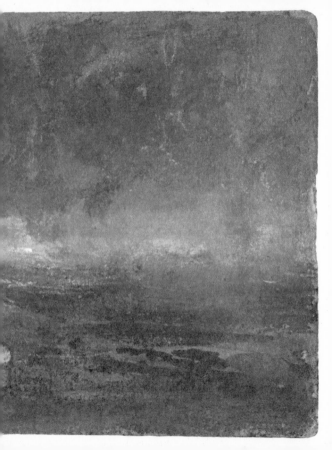

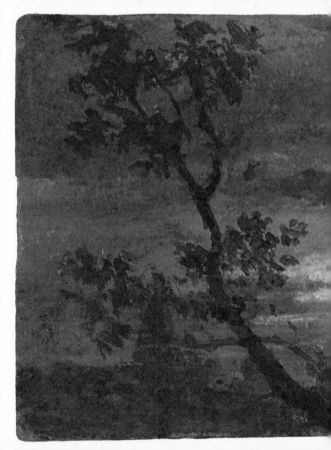

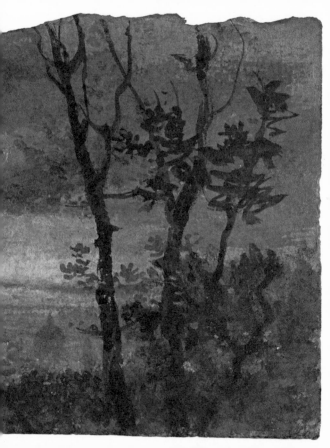

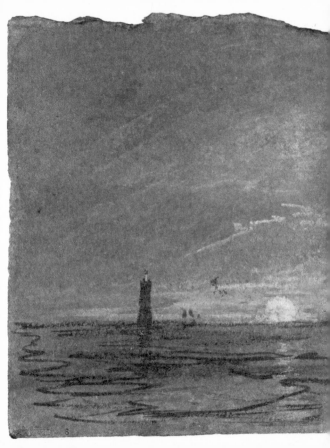

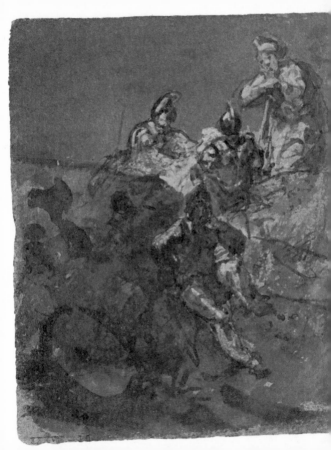

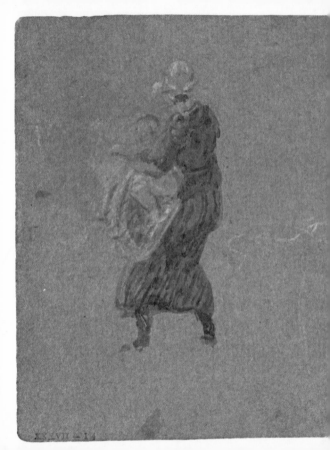

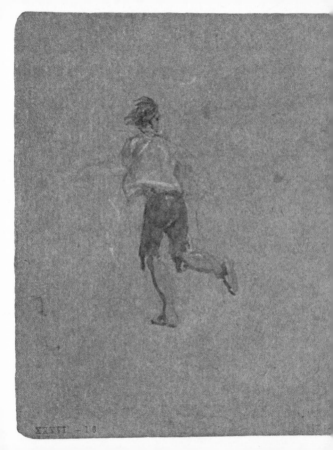

XXXVI - 16

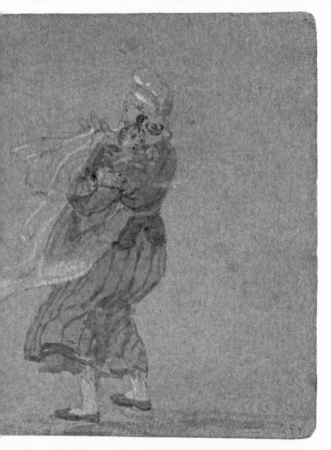

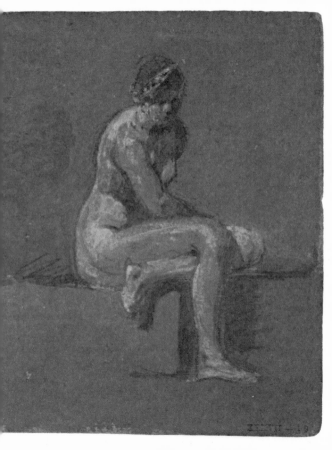

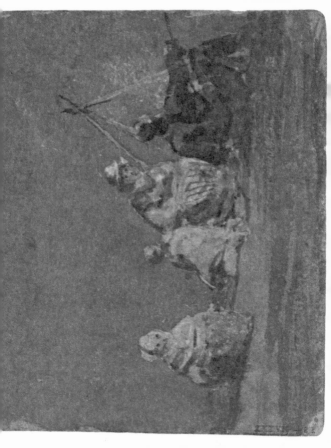

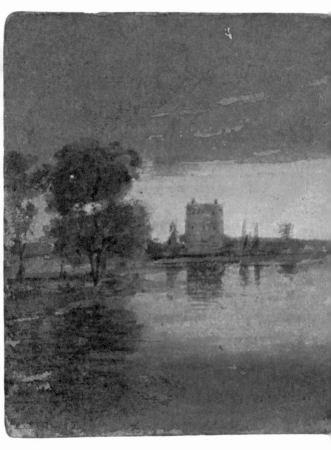

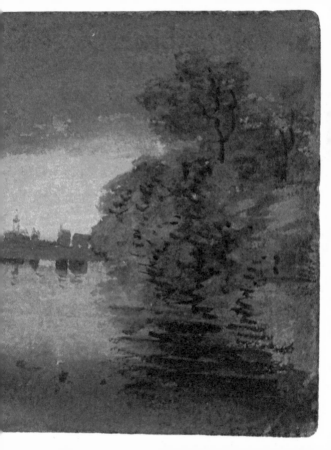

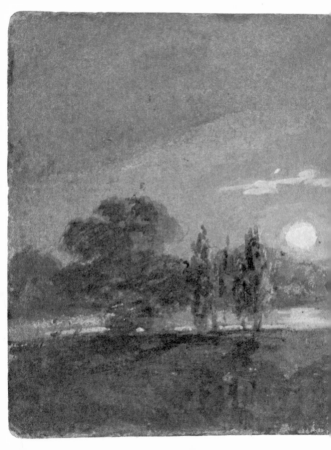

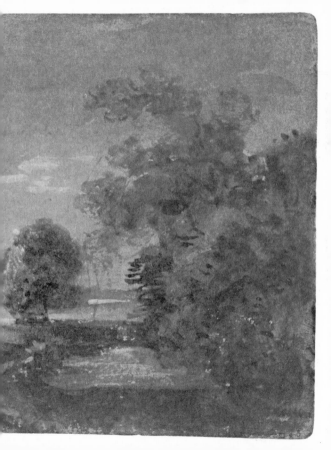

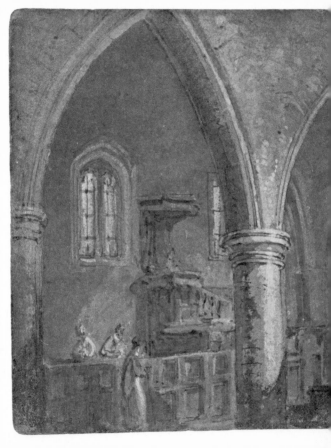

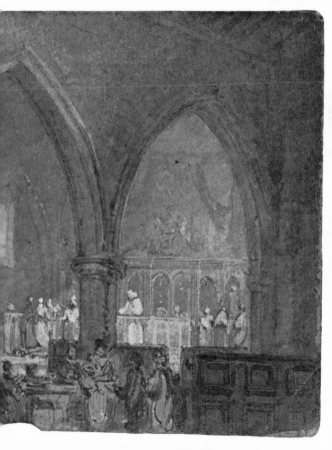

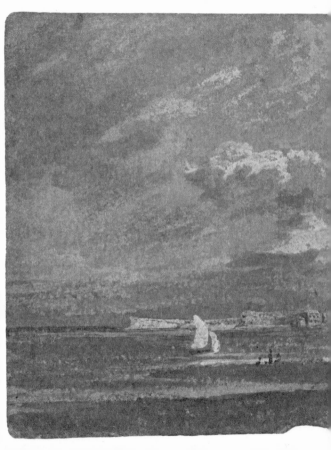

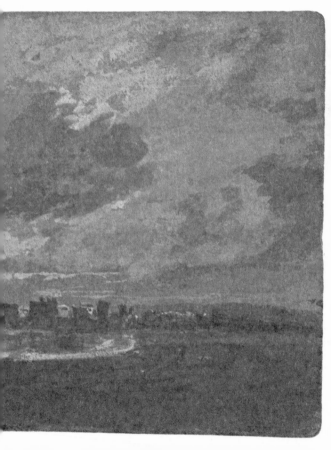

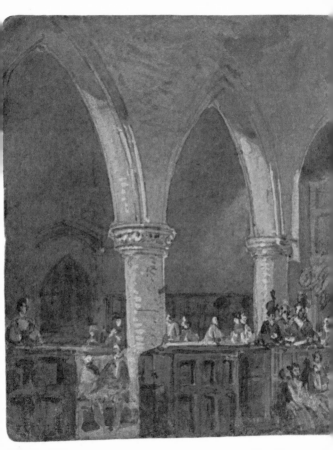

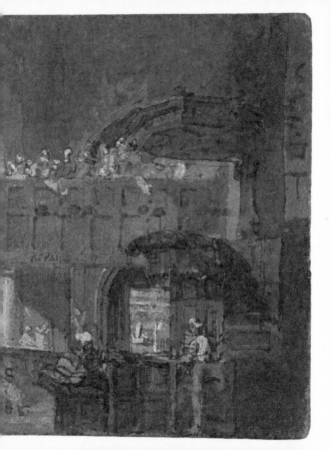

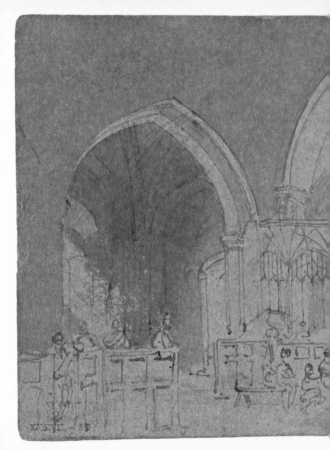

XXXII. 30

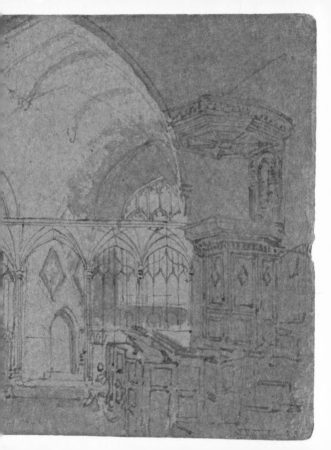

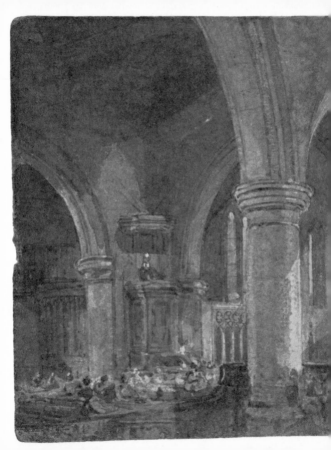

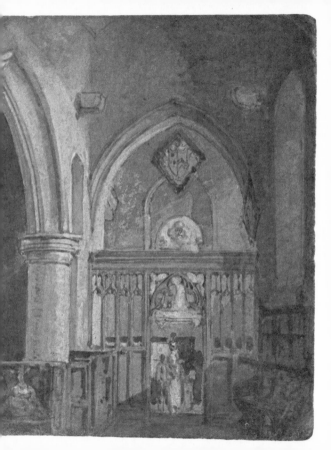

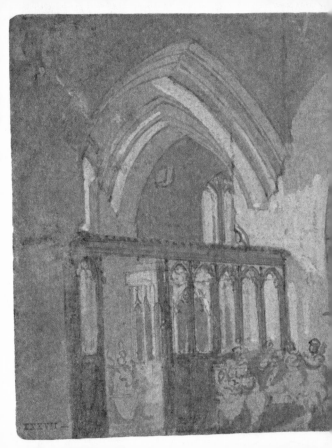

XXXVII.

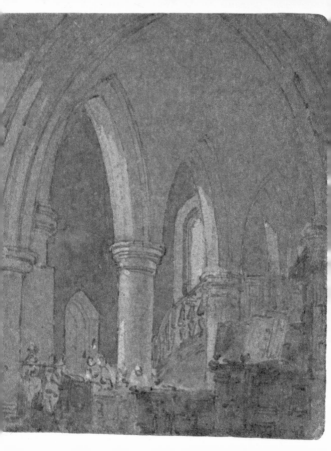

XXXVII — 3-6

XXXVII – 41

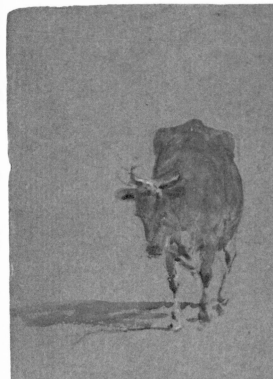

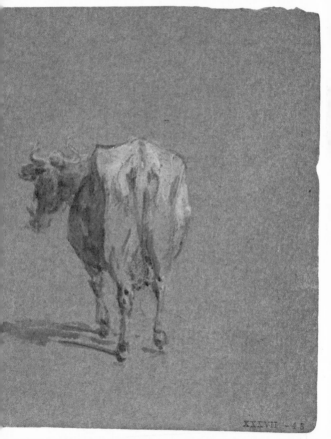

XXXVII - 45

XXXVII — 46

XXXVII — 17

XXXVII – 18

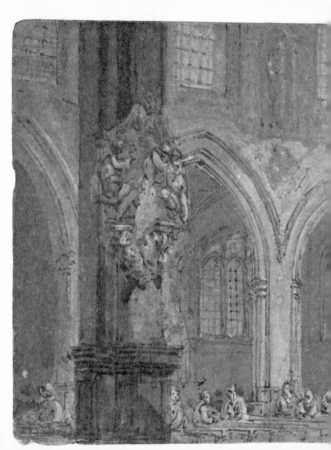

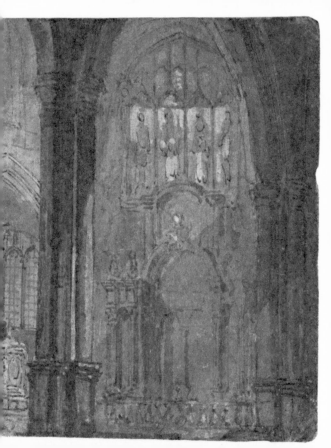

XXXVII · 54

XXXVII - 55

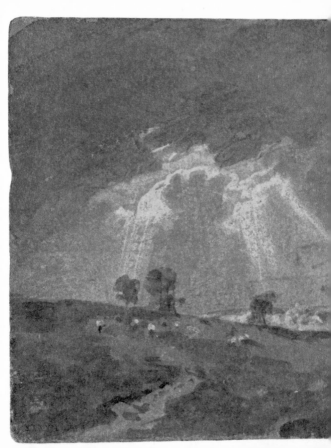

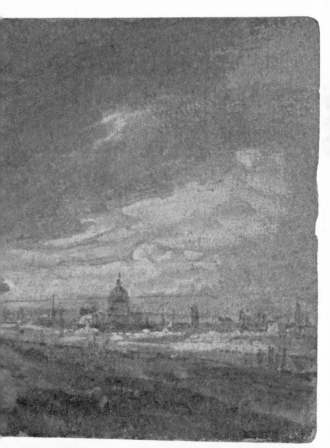

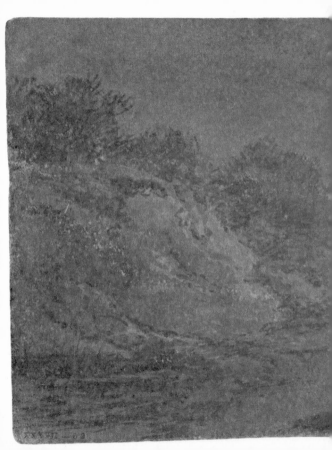

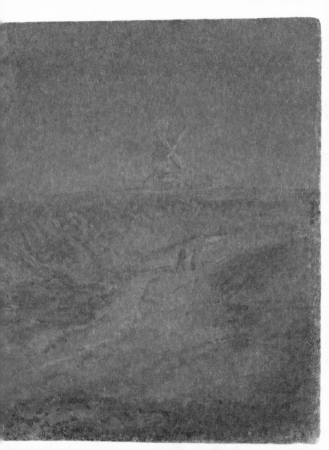

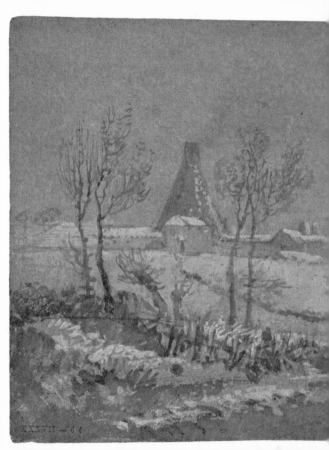

XXXVII—64

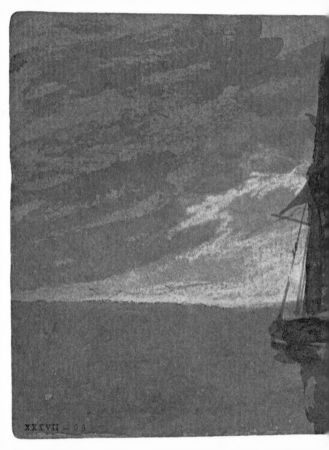

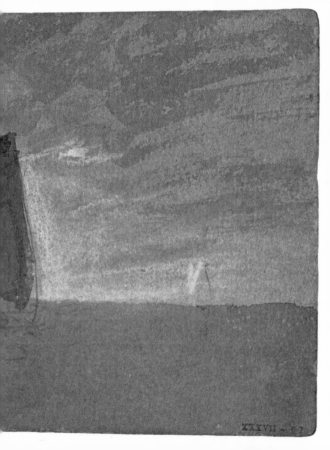

XXXVII – 67

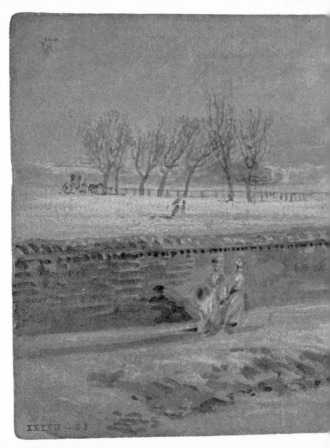

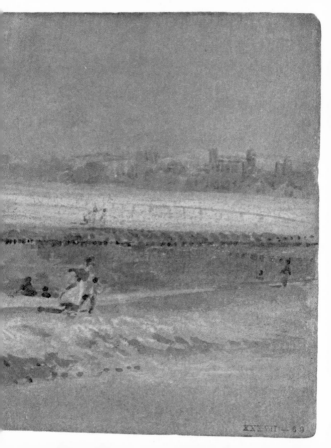

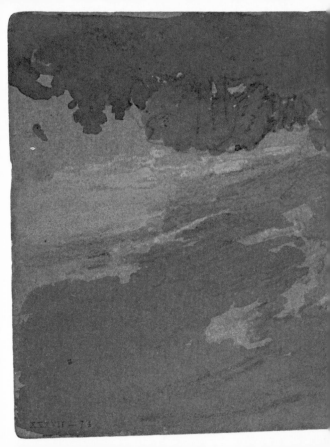

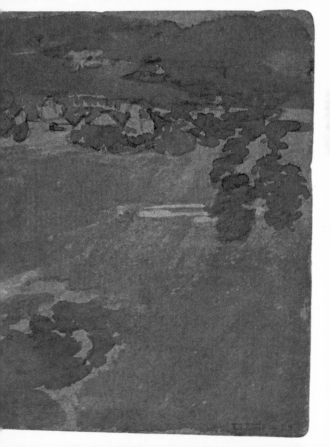

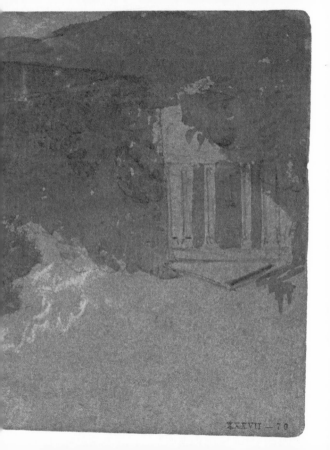

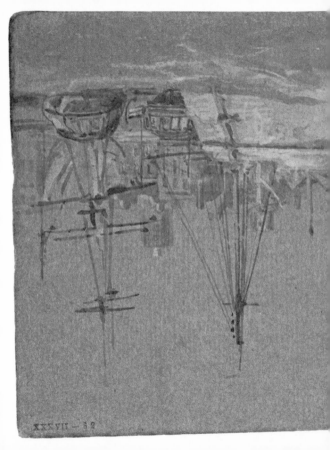

XXXVII – 52

XXXVII - 65

XXLVII — 8-8

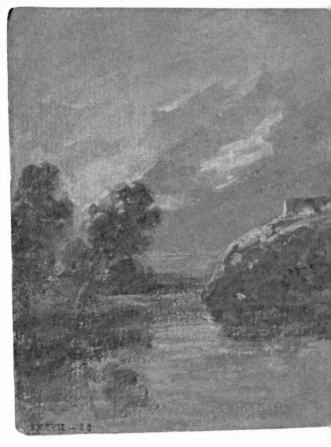

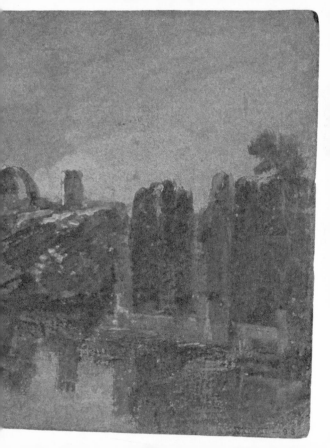

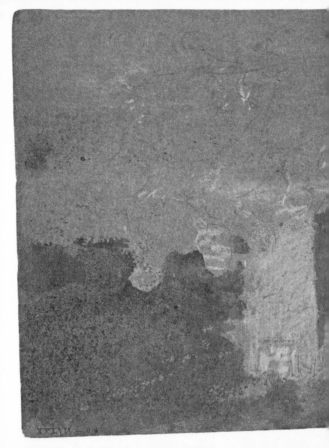

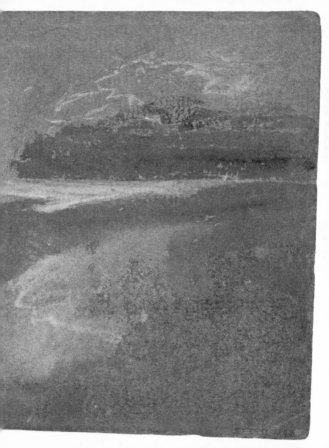

XXXVII - 100

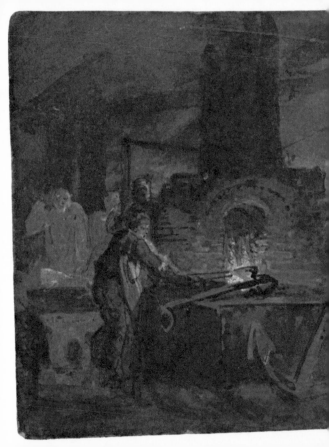

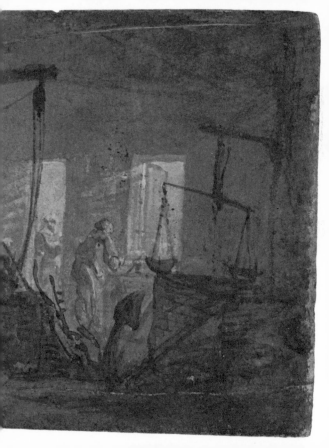

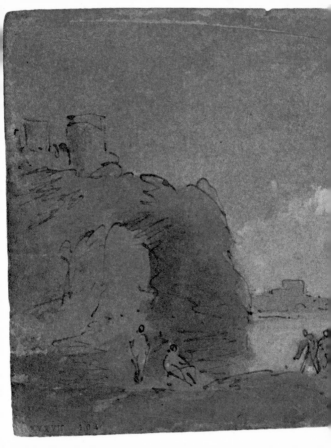

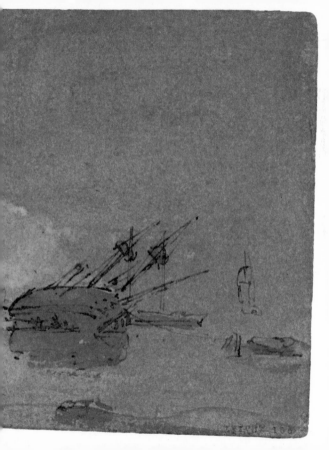

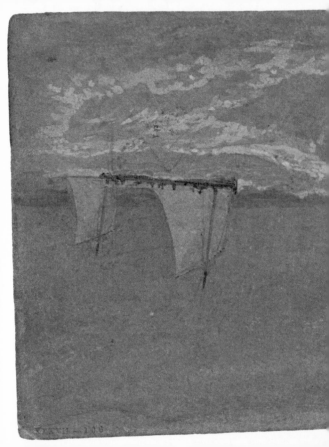

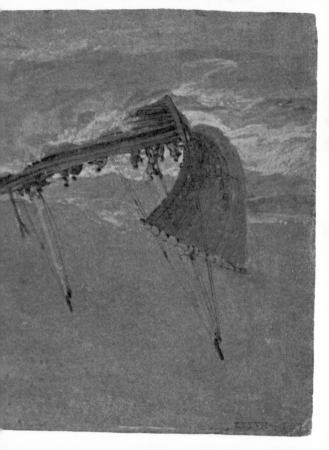

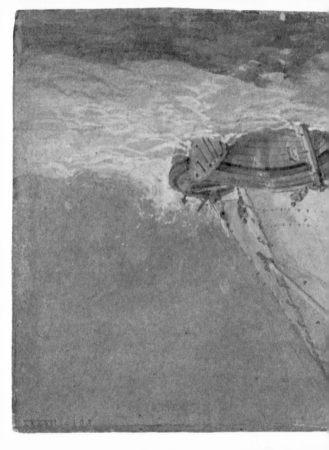

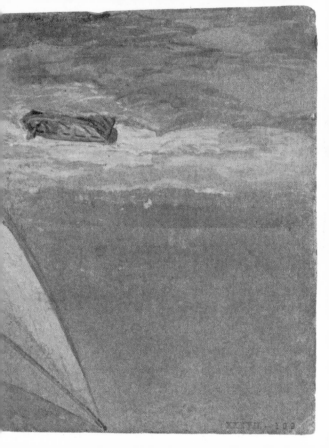

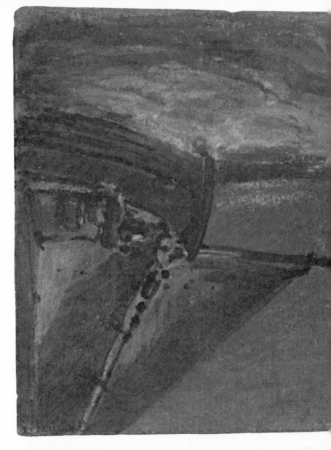

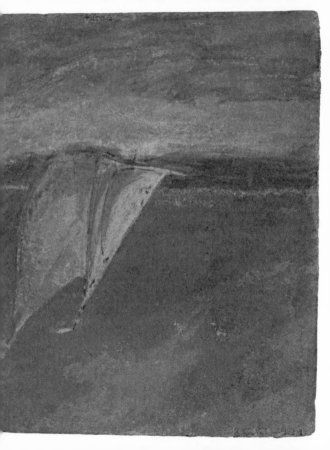

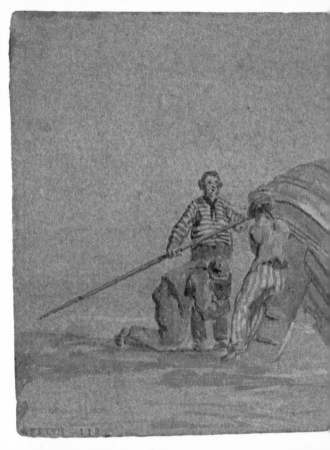

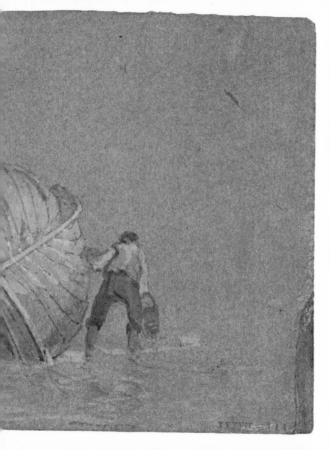

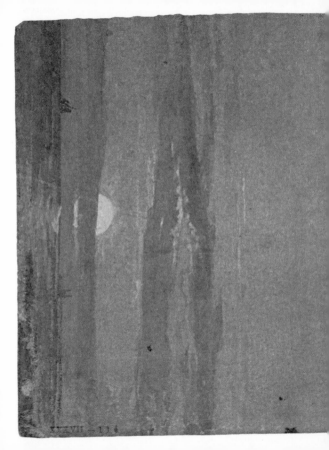

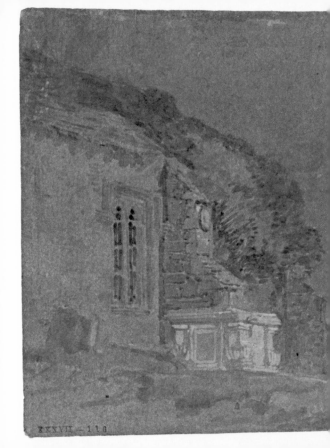

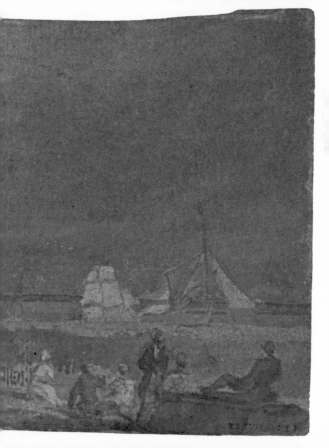

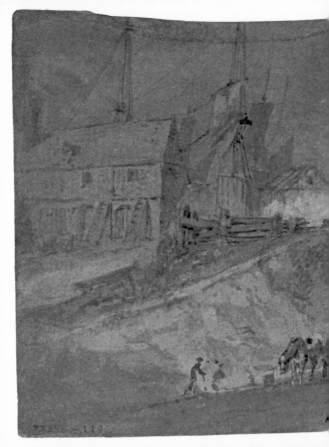

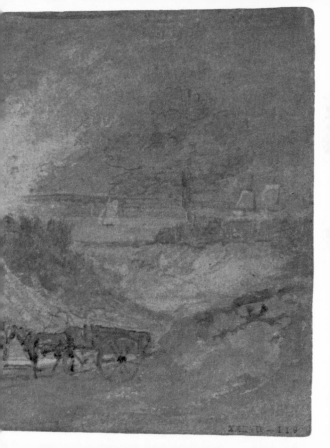

XLVIII – 119

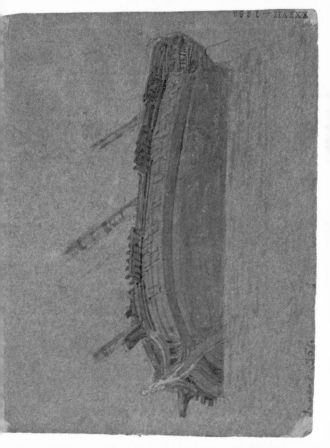

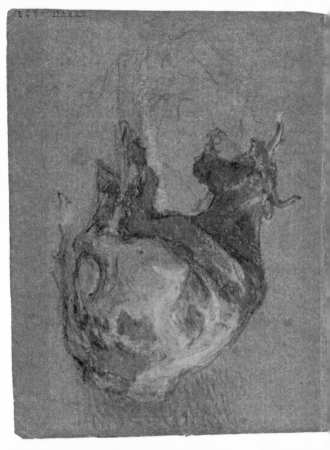

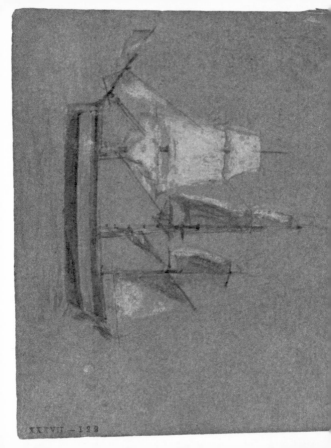

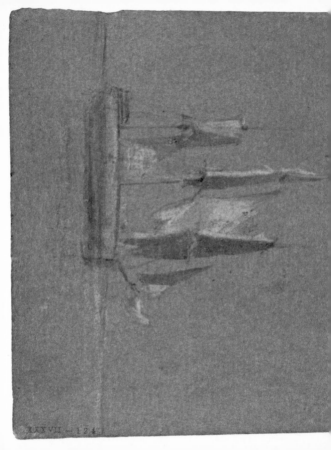